Difficult Chickens

COLORING BOOK

Illustrated by Sarah Rosedahl

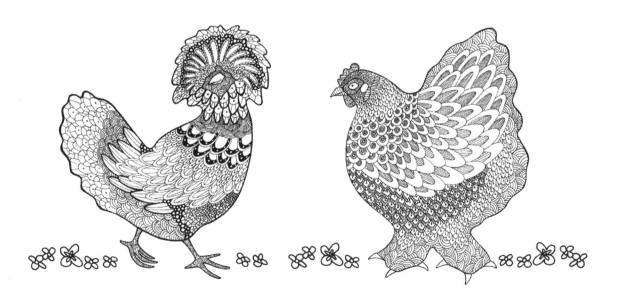

ISBN-13: 978-0692601945 (Tolba Farm Press)
ISBN-10: 0692601945

www.srosedahl.com

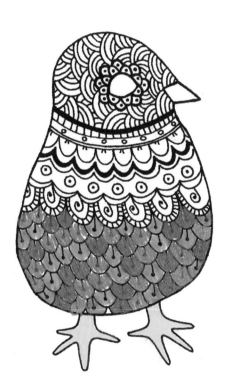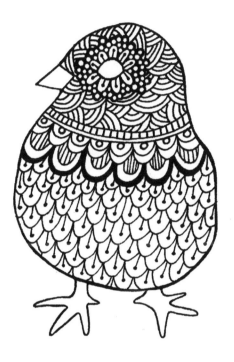

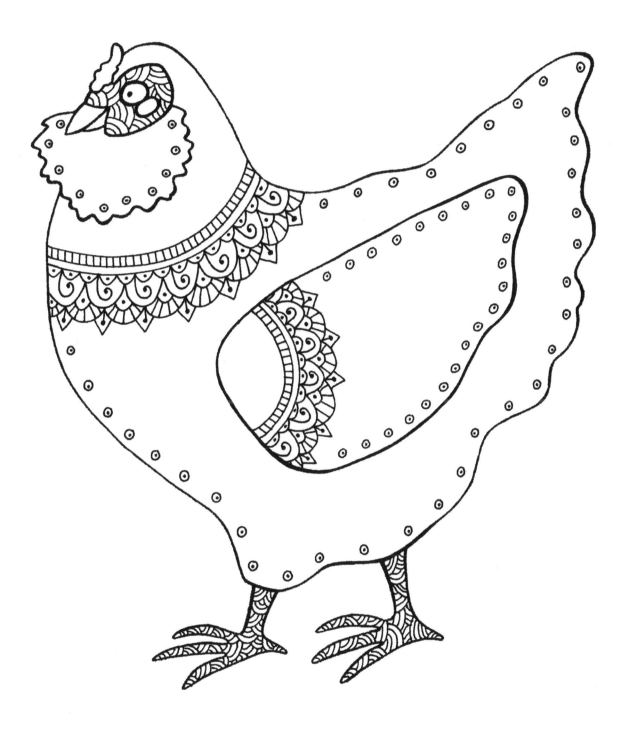

Ameraucana

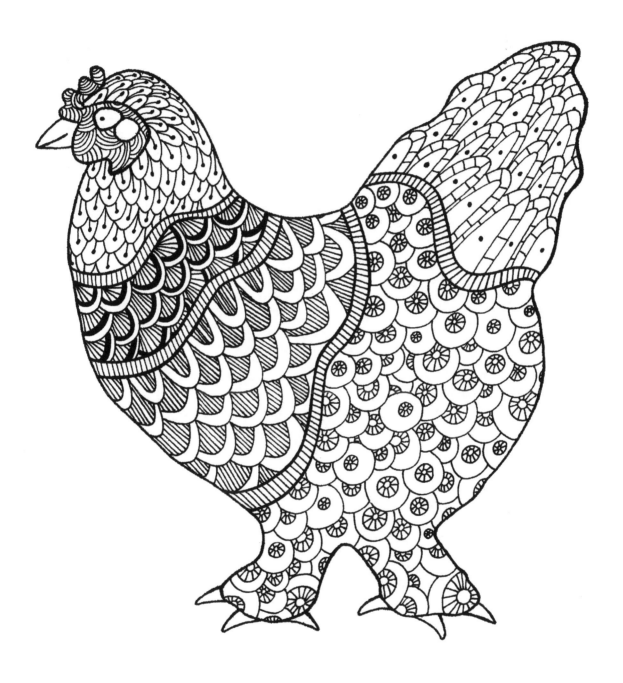

Brahma

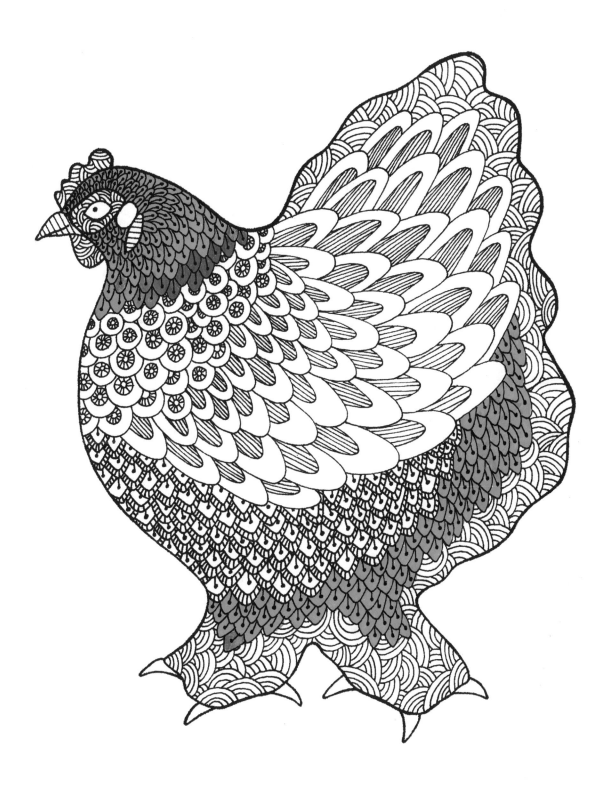

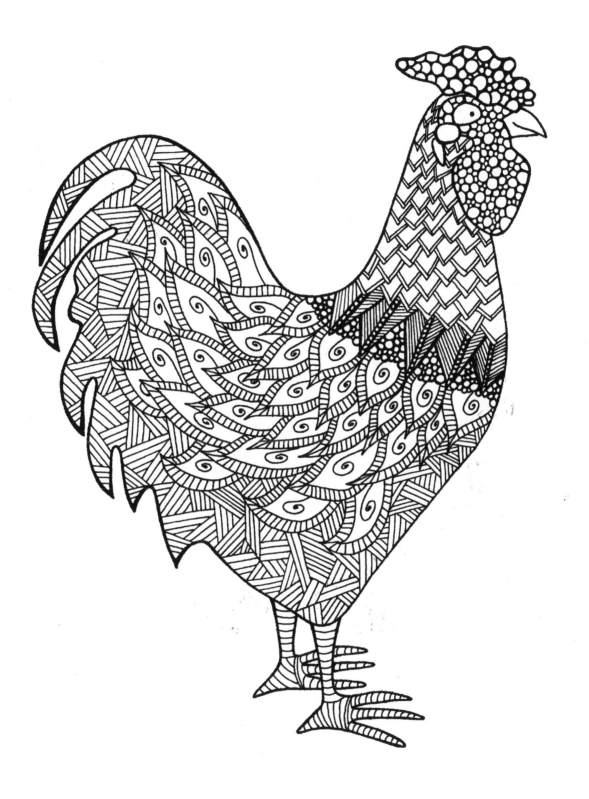

Derbyshire Redcap

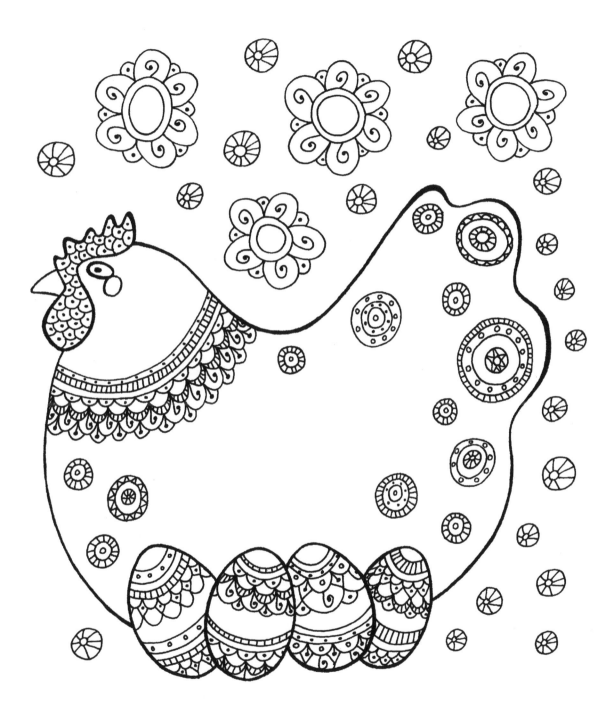

Easter Egger

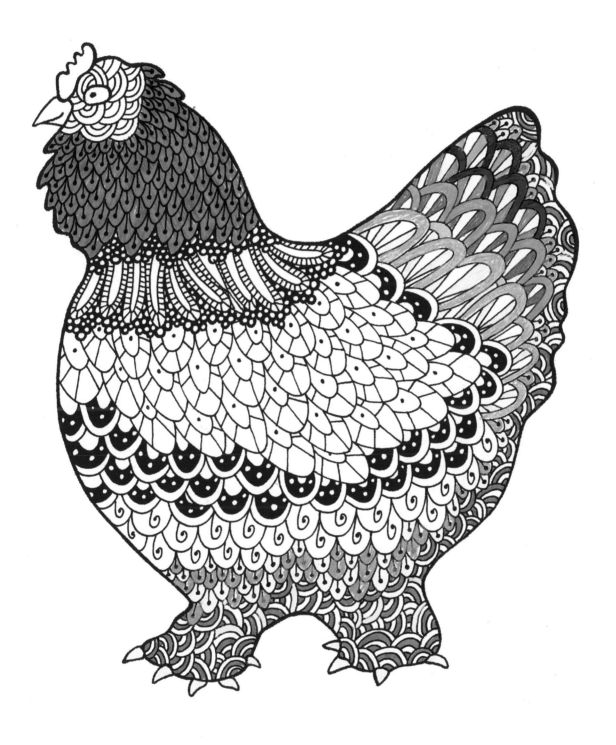

Faverolles

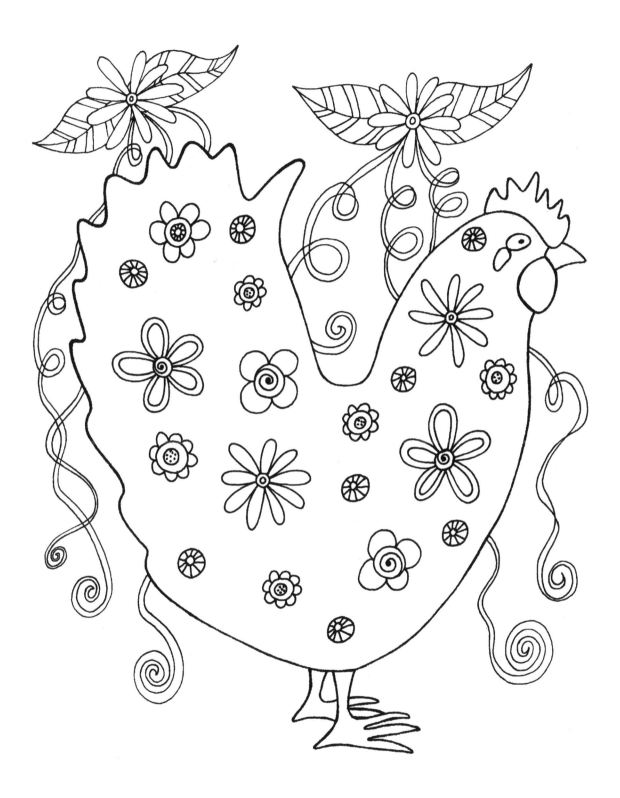

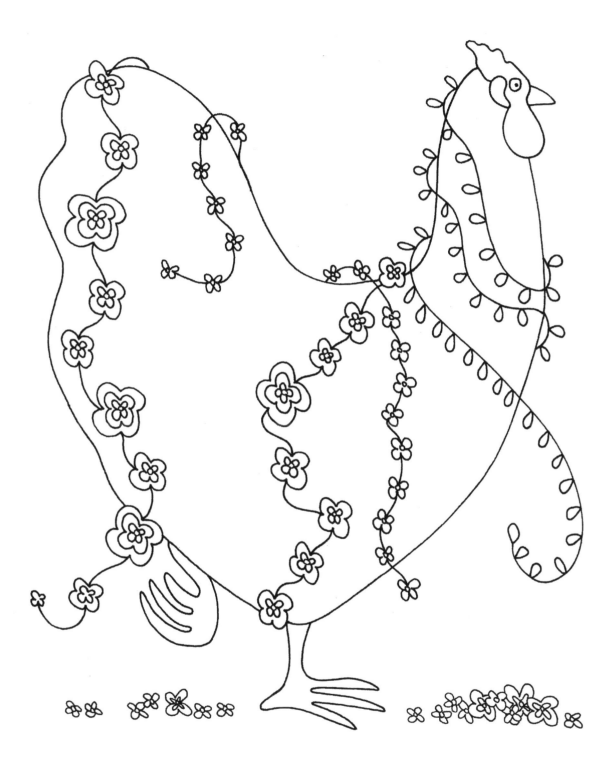

Hamburg

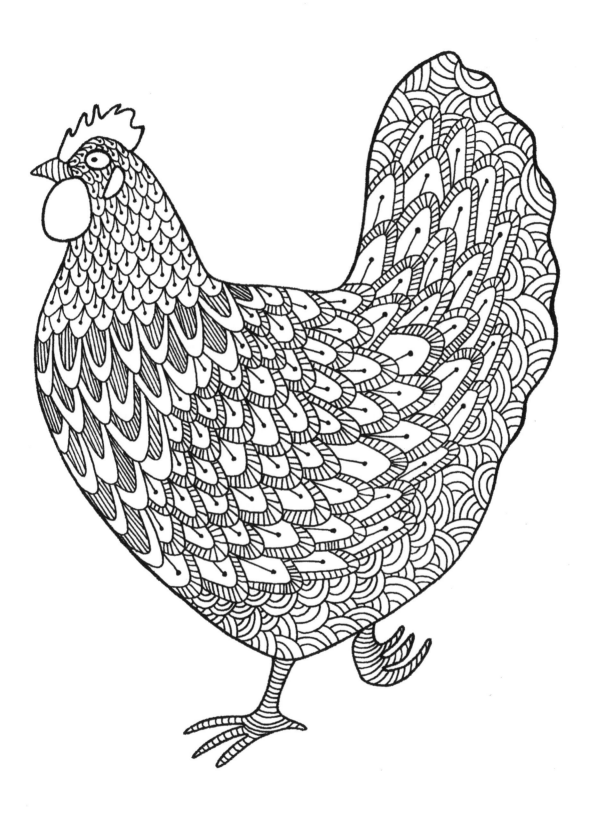

Iowa Blue

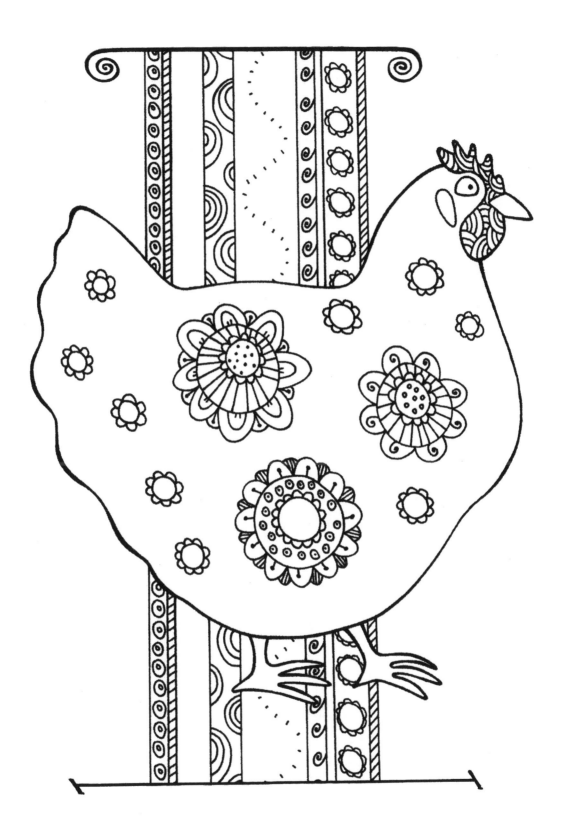

Jersey Giant

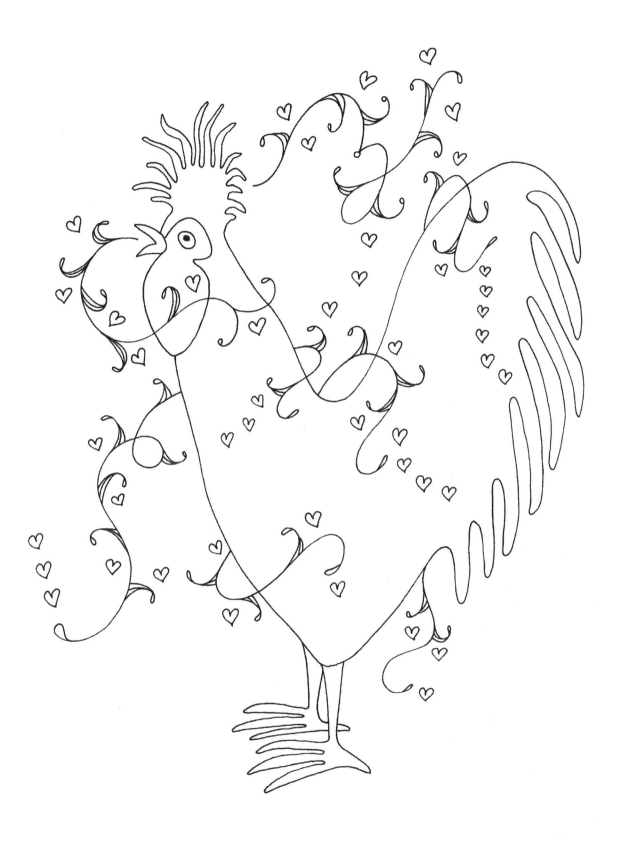

K osovo Long Crowing Rooster

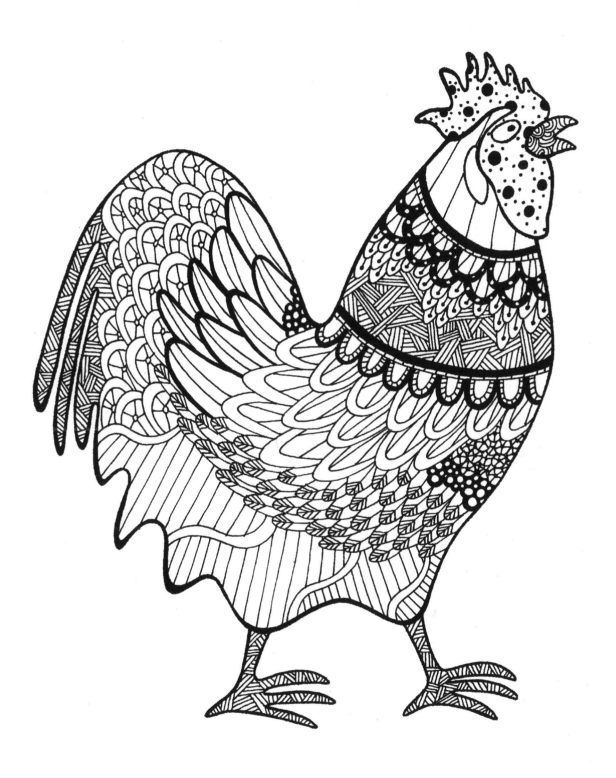

Leghorn

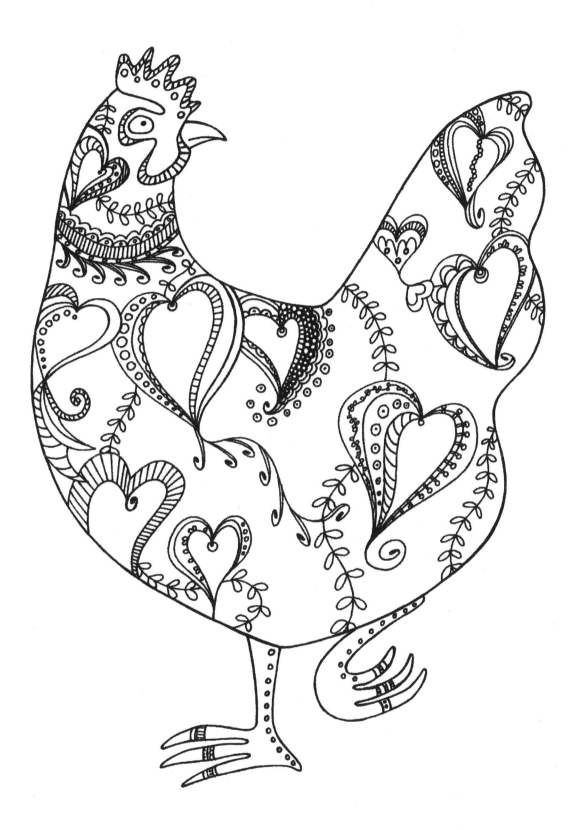

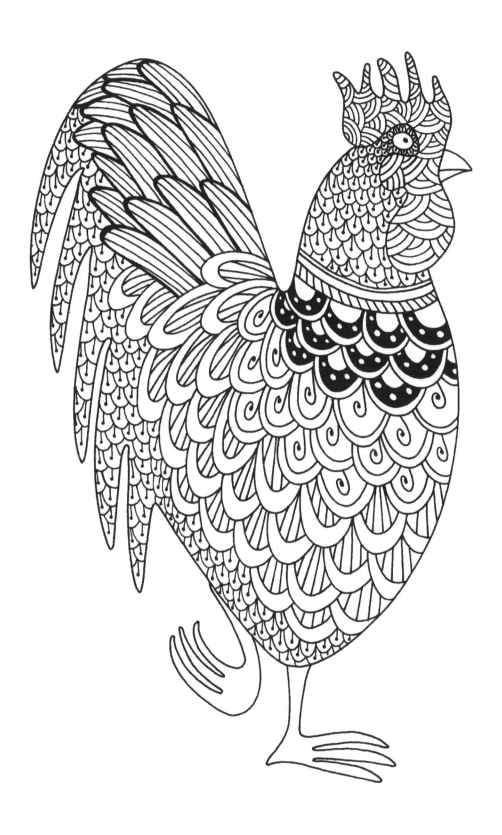

New Hampshire Red

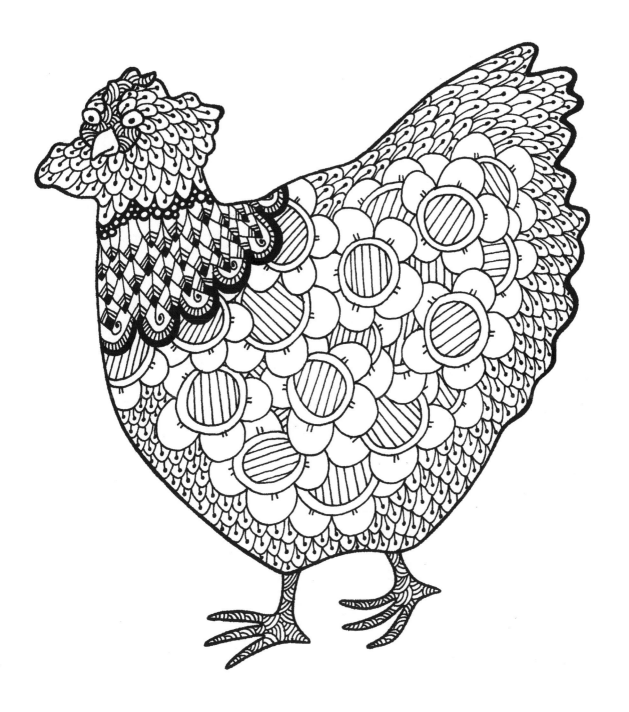

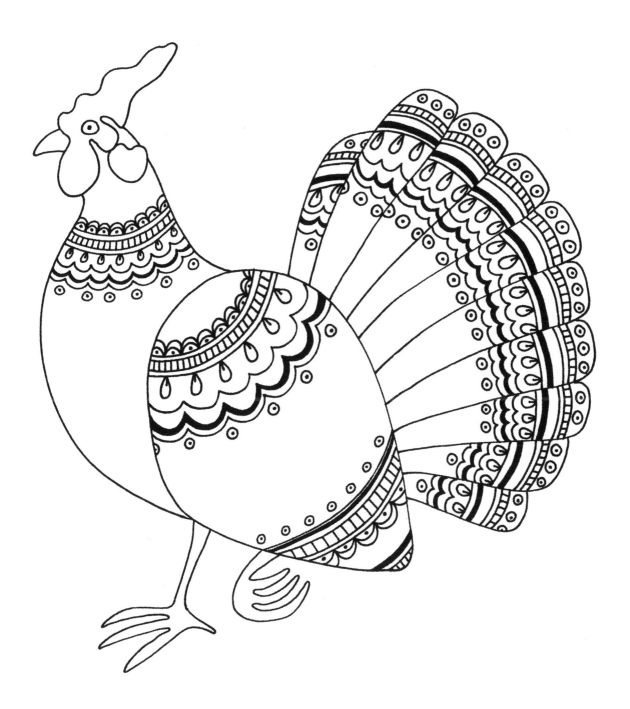

Rosecomb

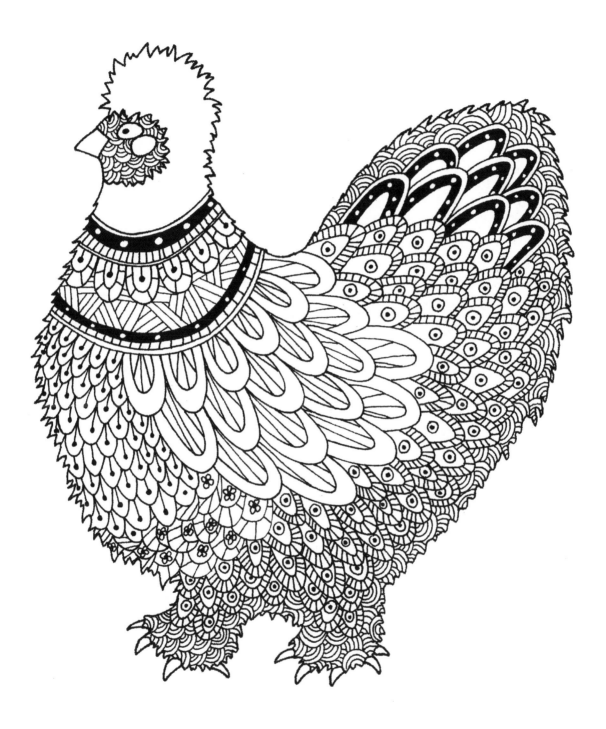

Silkie

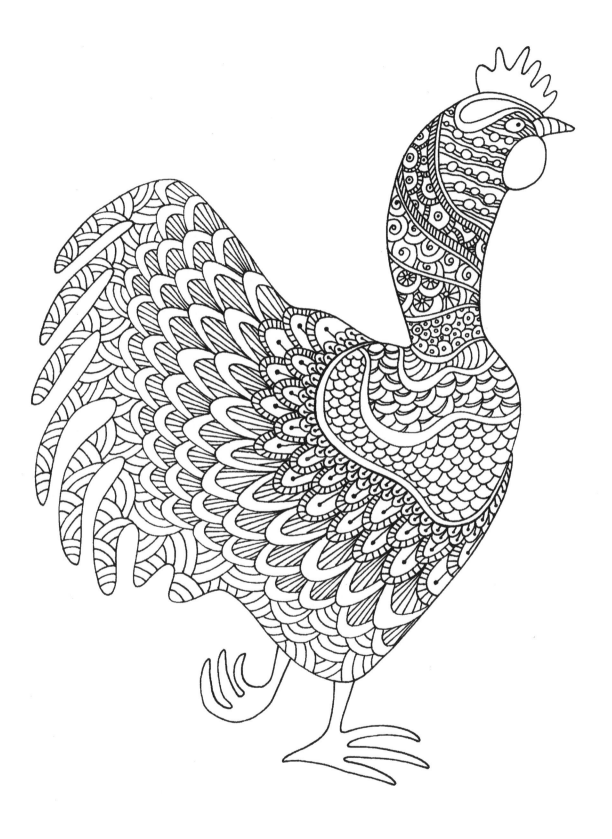

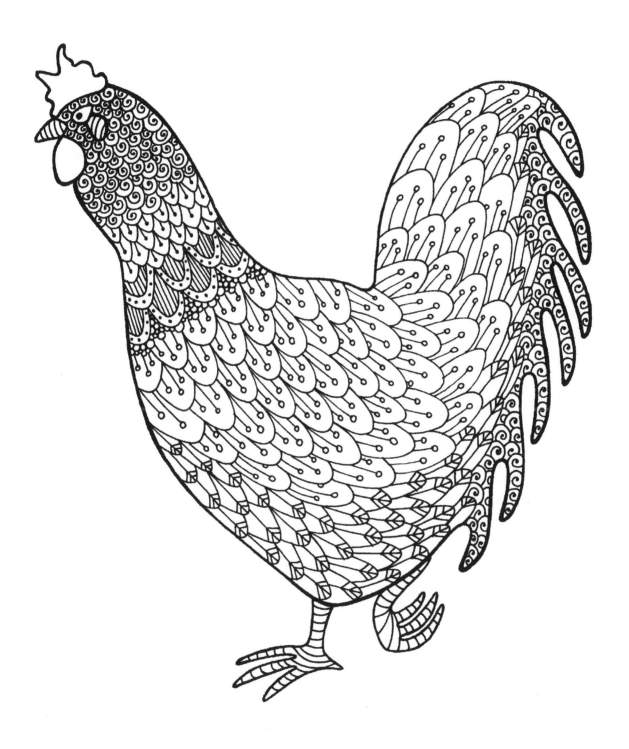

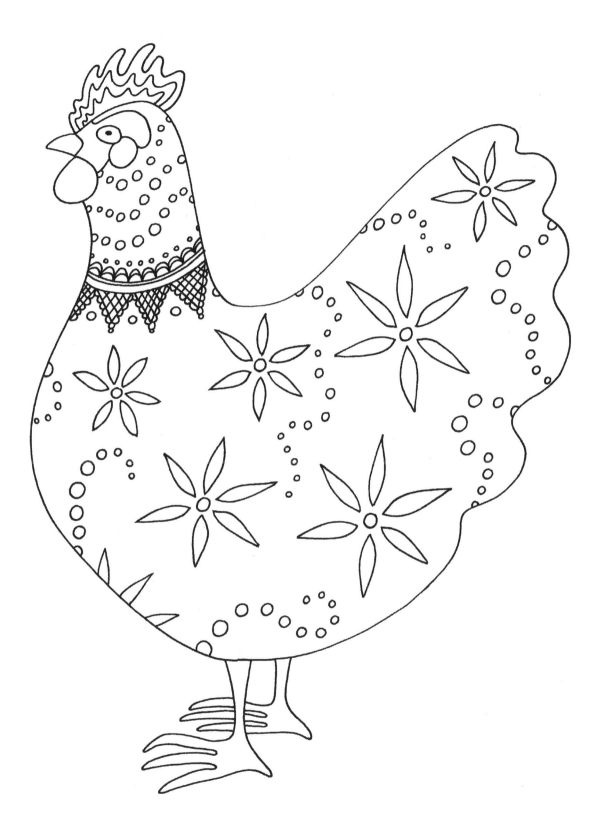

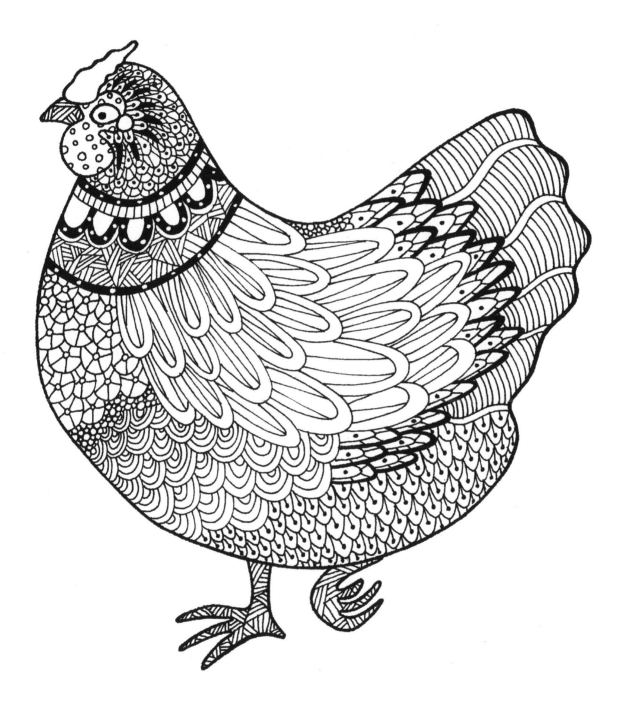

Wyandotte

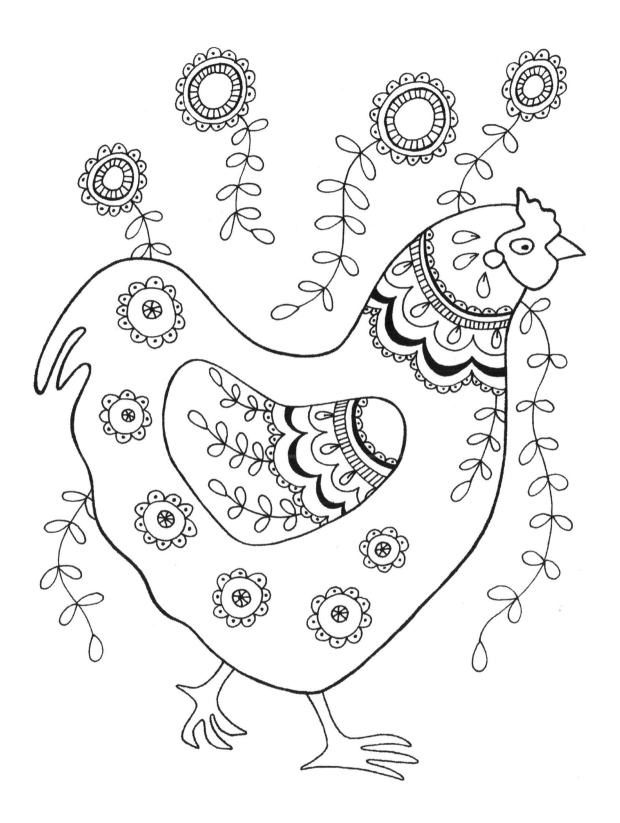

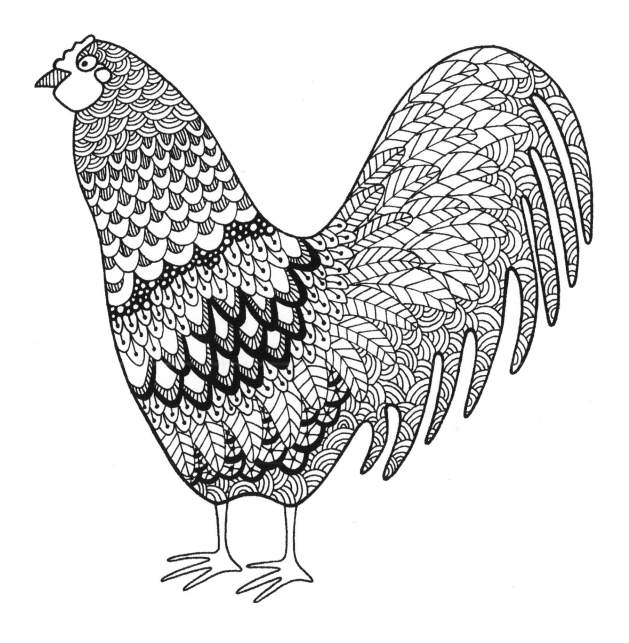

Yokohama

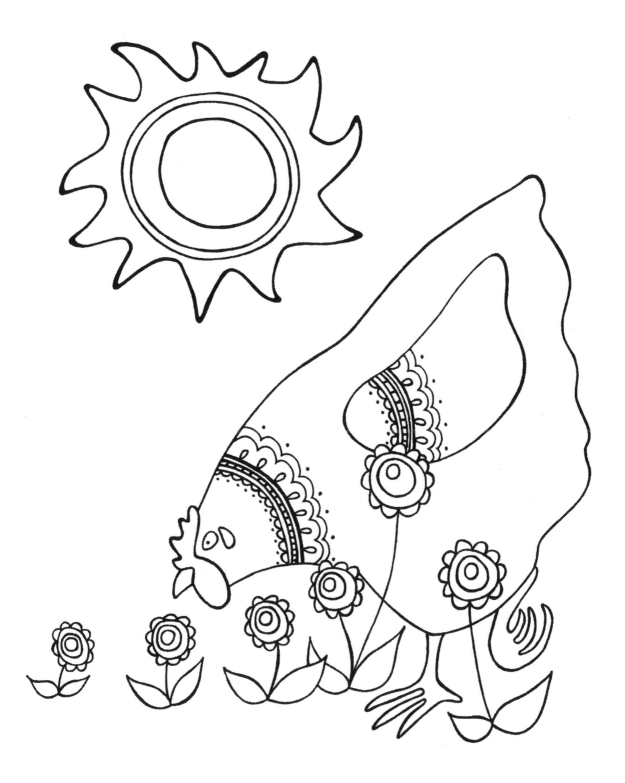

Made in the USA
Lexington, KY
10 December 2016